THE WATSON GORDON
LECTURE 2007

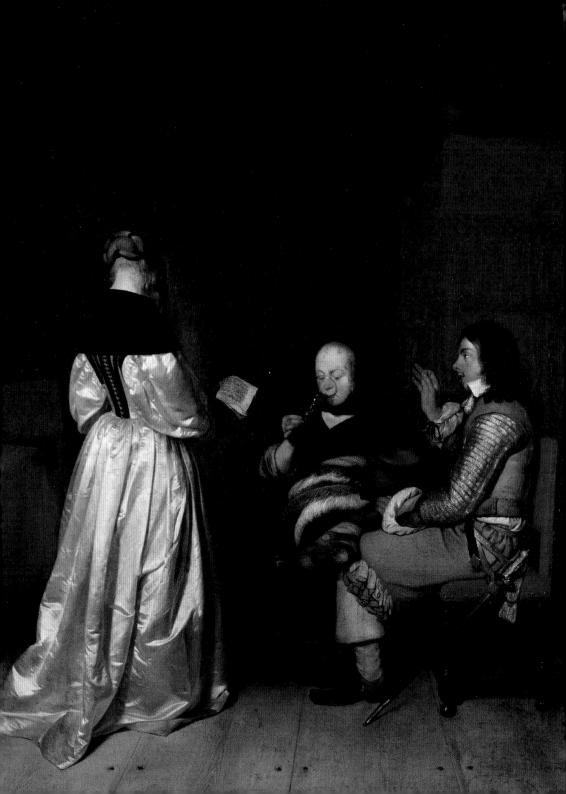

THE WATSON GORDON
LECTURE 2007

# Sound, Silence, and Modernity in Dutch Pictures of Manners

## MARIËT WESTERMANN

NATIONAL GALLERIES OF SCOTLAND

*in association with*

THE UNIVERSITY OF EDINBURGH

*and*

VARIE

Published by the Trustees
of the National Galleries of Scotland, Edinburgh
in association with The University of Edinburgh and VARIE
© The author and the Trustees of the National Galleries of Scotland 2010
ISBN 978 1 906270 25 4
Frontispiece: Frontispiece: Gerard ter Borch, *A Singing Practice*, 1655,
National Gallery of Scotland (Bridgewater Loan, 1945)
Designed and typeset in Adobe Arno by Dalrymple
Printed and bound on Arctic Matt 150gsm
by OZGraf SA, Poland

# FOREWORD

The publication of this series of lectures has roots deep in the cultural history of Scotland's capital. The Watson Gordon Chair of Fine Art at the University of Edinburgh was approved in October 1872, when the University Court accepted the offer of Mr Henry Watson C.A. and his sister Frances to endow a chair in memory of their brother Sir John Watson Gordon (1788–1864). Sir John, Edinburgh's most successful portrait painter in the decades following Sir Henry Raeburn's death in 1823, had a European reputation, and had also been President of the Royal Scottish Academy. Funds became available on Henry Watson's death in 1879, and the first incumbent, Gerard Baldwin Brown, took up his post the following year. Thus, as one of his successors, Giles Robertson explained in his inaugural lecture of 1972, the Watson Gordon Professorship can 'fairly claim to be the senior full-time chair in the field of Fine Art in Britain'.

The annual Watson Gordon Lecture was established in 2006, following the 125th anniversary of the Chair. We are most grateful for the generous and enlightened support of Robert Robertson and the R.& S.B. Clark Charitable Trust (E.C. Robertson Fund) for this series which demonstrates the fruitful collaboration between the University of Edinburgh and the National Galleries of Scotland.

The second annual lecture, given on 14 November 2007, was by Mariët Westermann, then Director of the Institute of Fine Arts, New York University. Professor Westermann is a widely-published scholar in the field of seventeenth-century Dutch art, author of monographs on Rembrandt, Vermeer and Jan Steen, the subject of her PhD. Her highly stimulating lecture, building on the thematic approach of her book on Dutch interiors, explored the pensive and the raucous, the reflective and the ribald, in an engagingly wide range of paintings.

RICHARD THOMSON
*Watson Gordon Professor of Fine Art,*
*University of Edinburgh*

JOHN LEIGHTON
*Director-General,*
*National Galleries of Scotland*

[5]

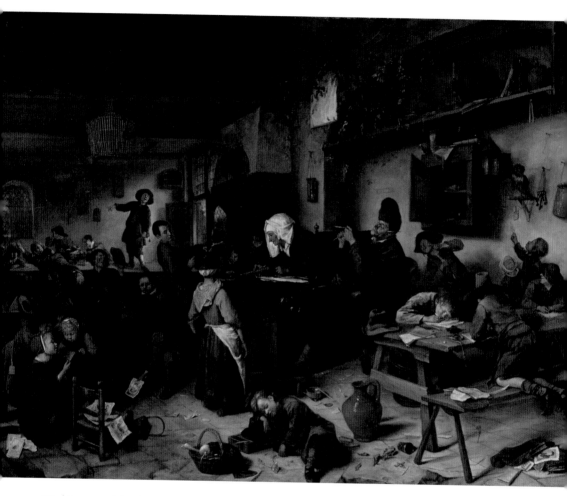

FIG.1 | JAN STEEN (1625/6–1679)
*A School for Boys and Girls*, 1670
Oil on canvas  81.7 × 108.6 cm
Purchased by Private Treaty with the aid of the National Heritage
Memorial Fund 1984
National Gallery of Scotland, Edinburgh

# SOUND, SILENCE, AND MODERNITY IN DUTCH PICTURES OF MANNERS

The rise of silence is a defining aspect of seventeenth-century painting in the Dutch Republic. You may say that all painting is silent, and indeed, perhaps it has been. But painting in its long history often resisted the idea that it should be mute. In the seventeenth-century Netherlands it quieted itself down as the medium set itself on the road to modernity. Few painters were more instrumental in that development than Gerard ter Borch and Johannes Vermeer (frontispiece). But noisy Dutch painters long held down the fort for sound. One of the best, Jan Steen, is one of the heroes of that resistance, and one of his most soundful paintings is in the National Gallery of Scotland (fig.1).

'Painting is silent poetry, and poetry is painting with the gift of speech.' Simonides, the Greek lyric poet, is now remembered mostly for this aphorism. The idea that painting is mute poetry, and poetry a painting that speaks, has had powerful and varied issue. It has been forever quoted, debated, and transformed by philosophers and art critics, and interpreted in painting as well as poetry by practitioners of those arts. In the first century AD, Plutarch transmitted Simonides' statement directly – indeed, it survives thanks to his quotation. But by then Horace, the influential codifier of Roman poetics, had already condensed it into a statement at once simpler and richer in its potential for interpretation. 'As is painting, so is poetry,' is the way Horace phrased the parallel between what thus became the sister and rival arts. In ancient literary criticism, the analogy served to elucidate the qualities of literary diction, rather than to speak of painting per se, but in the Renaissance, painters and theorists of painting took advantage of the implied parity of pictures and poetry. In treatises, poems, and the most casual references, they began to refer to it as evidence of the high intellectual value of painting. If painting could imitate and represent life with the same expressive force as poetry,

it could compete with the literary arts for social standing and remuneration.

The silence of painting became a trope of Renaissance texts on art, both in Italy and north of the Alps. Painters appealed to Horace's analogy in their increasingly bold efforts to upgrade the standing of their manual craft to that of a liberal art. They positioned painting as a creative enterprise characterised by the artist's freedom, akin to that of the poet, to invent whatever he or she pleased as long as it was within the bounds of decorum, the appropriate matching of topic and representational means. Other arguments were mustered to demonstrate painting's parity with poetry, or even its superiority. Leonardo acknowledged that 'poetry is the science of the blind and painting that of the deaf. But painting,' he concluded, 'is nobler than poetry because it serves the nobler sense' – that of sight. In the Netherlands, artists liked to claim that painting was superior to poetry because the ancients rewarded it better with golden chains and other riches. Dutch writers loved to cite the case of Alexander the Great, who gave up his concubine to his court painter Apelles. This set of arguments may strike some as a particularly Dutch kind of proof – money and sex as measures of social arrival – but they surfaced in Italy as well.

Inevitably, however, those who championed the Horatian analogy on painting's behalf found that it would lead them back to Simonides, and to the inescapable muteness of painting. Silence may be golden, but the repetitiveness with which art writers elaborated this point over the past 500 years suggests a certain anxiety that speech and sound offer advantages that might yet award the palm of victory to the literary arts. How could painting develop a narrative in sequence, extending through time, in the manner of poetry? How could painting ever match the expressive nuances of the human voice and the sounds of nature? These were not abstract concerns, especially in a time when much literature was still communicated orally and in which our predominant culture of private, silent reading was still under development. Religious and history painters were for ever taking up the challenge of creating narrative sequences in paint. The most obvious solution was the transposition of sequential manuscript painting onto altarpieces by lining up scenes comic-strip style, as Duccio did in his grand *Maesta* in Siena (fig.2). Later, painters tried nestling as many narrative episodes as possible

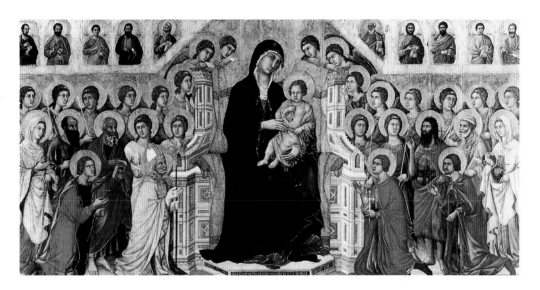

FIG.2 | DUCCIO (1260–1318)
*Maesta: Madonna in Majesty*
Museo dell' Opera, Metropolitana, Siena

into unified landscapes, as Hans Memling did in his theatrical presentation of the *Passion of Christ* (Galleria Sabauda, Turin), using spatial differentiation as an analogue for temporal progression. Others sought to work all manner of sound, from speech and music to wind and even thunderclaps into their paintings. In an unusually lively portrait, in the National Gallery of Scotland, Frans Hals had his sitter brandish a giant jawbone to signal his biting speech (fig.3). This man, named Verdonck, was notorious for his sharp eloquence. The picture appears to give the lie to the saying that words cannot hurt you.

In short, from Antiquity through the Middle Ages, painters encountered tasks that required experimentation with narrative sequence and sound equivalency. But while these problems were typically specific to assignments, such as representing all of the Sorrows of the Virgin on one page or in one altarpiece or

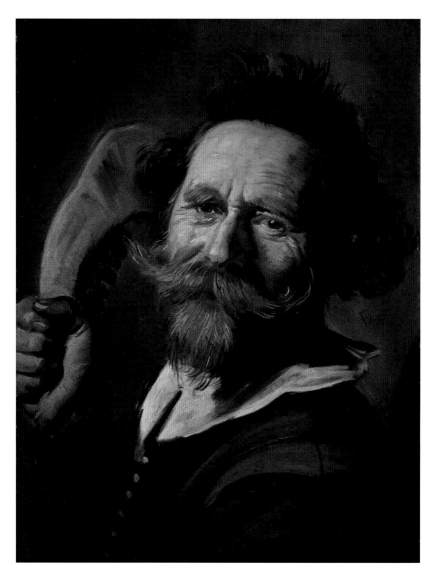

FIG.3 | FRANS HALS (1580/5–1666)
*Verdonck*
Oil on panel 46.7 × 35.5 cm
Presented by John J. Moubray of Naemoor 1916
National Gallery of Scotland, Edinburgh

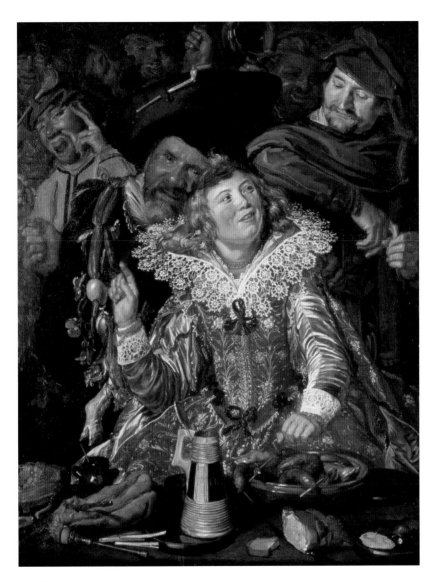

FIG.4 | FRANS HALS (1625/6–1679)
*Merrymakers at Shrovetide*, 1616–17
Oil on canvas 131 × 99 cm
Bequest of Benjamin Altman, 1913
The Metropolitan Museum of Art, New York

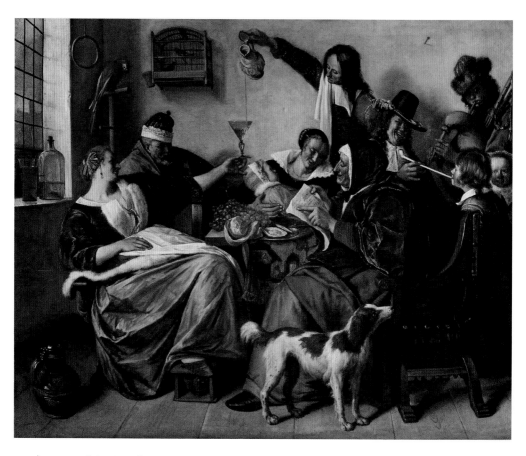

FIG.5 | JAN STEEN (1625/6–1679)
*'The Way You Hear it, is the Way You Sing it'*, 1665
Oil on canvas 134 × 163 cm
Mauritshuis, The Hague

capturing a man's talent for speech, they became medium-specific interests once Renaissance scholars and artists created a humanistic theory of painting to match ancient poetics and its revivals. And in northern Europe, once the Reformation had foreclosed painting's traditional functions while promoting others, a proto-modern system of painting arose in which it became possible and even imperative for painters to pursue humanistic tropes for critical success and market position. Under these conditions, getting paintings to *sound* right emerged as one special interest for Dutch painters of manners.

Paintings of manners is the term I have come to prefer for what are usually called genre paintings, that is, generalised pictures of the social life of the good, the bad, the mad, and the dangerous to know. The preoccupation of Dutch painters with sound first occurred to me when I was looking intently at the paintings of Jan Steen, a noisy Dutch painter if ever there was one. In a fine self-portrait, he presents himself as loudmouth, a drink near at hand, strumming the lute and issuing a hearty guffaw (*Self-portrait as a Lutenist*, Museo Thyssen-Bornemisza, Madrid). And in a large painting in the Mauritshuis, he gives us his family, at least his pictorial family, hooting up some country ditty to the bagpipes (fig.5). 'As the Old Sing So Pipe the Young,' is the governing proverb inscribed on the song sheet at the picture's centre –soundful words for a noisy picture. Silence here is pewter at best. And in the National Gallery of Scotland's *A School for Boys and Girls* (see fig.1), we see how well Steen's kids and their friends are learning from their elders, turning up the din as their male teacher affects deafness and his female associate readies her correctional apparatus. The tone is set by the howling Apollo junior, teetering on the table at the back of the room. Steen was exceptionally clever at figuring out new tactics for making painterly noise, generally favouring inelegant instruments such as fiddles, bagpipes, and drums; crockery and metalware crashing to the ground; gaping mouths; restless, spinning, topsy-turvy compositions of furniture and folks leaning alarmingly out-of-the perpendicular; rich and rapidly changing bright colours; and visibly forceful brushstrokes (*Gamblers Quarrelling*, Detroit Institute of Art, Detroit).

Many of Steen's predecessors and peers in paintings of manners made noise well, too. Clamorous revelry issues from the high-keyed colours and pressed

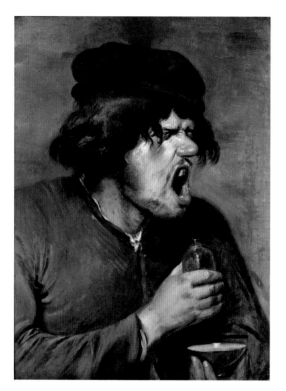
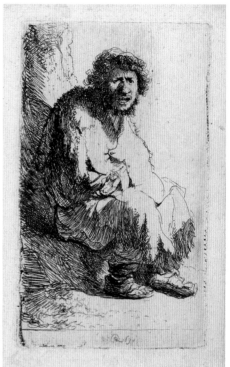

composition of Frans Hals's picture of revellers (fig.4). When Adriaen Brouwer's yokel coughs up a bitter drink, the guttural scraping seems audible (fig.6). We can almost hear the screechy tune produced by his swaying fiddler (Alte Pinakothek, Munich). As Brouwer's pictures suggest, bright colours are not required for pictorial noise: vigorous monochromes of physiognomically charged human figures will do perfectly well (see fig.12).

The paintings of Hals and Brouwer remind us that almost nothing will generate pictorial sound as effectively as the opened mouth, not least because opening one's mouth beyond a restrained utterance was considered very bad form – as it still is today in many societies. Rembrandt perfected this ploy in the deliberately unattractive *Self-portrait as Beggar* from 1630 (fig.7). The open mouth that

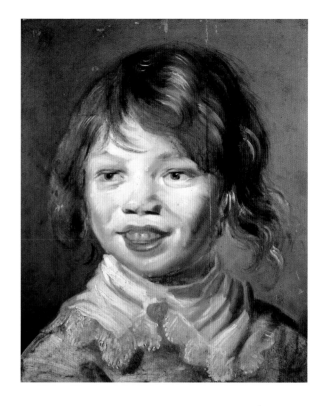

FIG.6 | ADRIAEN BROUWER (1606–1638)
*A Bitter Draught, c.*1630
Oil on wood 48 × 36 cm
Musée des Beaux-Arts, Dijon

FIG.7 | REMBRANDT VAN RIJN (1606–1669)
*Self-portrait as a Beggar,* 1630s
Etching 11.6 × 7 cm
Kupferstichkabinett, Staatliche Museen zu Berlin,
Berlin

FIG.8 | FRANS HALS (1580/5–1666)
*The Laughing Child*
Oil on panel 31 × 25 cm
Musée des Beaux-Arts, Dijon

flashes its teeth is a signature motif of Rembrandt's early works, and it shows him responding to market interests. Rembrandt must have been well aware of the clever use his contemporaries had been making of this earthy device throughout the 1620s. Frans Hals's laughing children owe their child-likeness in good measure to the fact that grown-ups were not supposed to bare their teeth (fig.8). Hendrick ter Brugghen's rakish violinist is such an overly exuberant adult (*A Boy Violinist,* Hascoe Collection and Dayton Art Institute, Ohio). His fiddler gains life from his dental specifics and near-audible vocalisation. Rembrandt, too, used the opened mouth to signal laughter and merriment, but more often in his works it registers pain, rage, or melancholy, as in his early painting of Christ suffering on the Cross (Church of le Mas d'Agenais, France).

[ 15 ]

The closely successive dates in the 1620s and 1630s of pictures with protagonists baring their teeth in completely different situations, by such ambitious artists as Hals, Ter Brugghen, Rembrandt, and Brouwer, suggest that the open-mouthed motif was commercially viable regardless of the painting's theme. Its market advantage was almost certainly enhanced by its humanist reputation as a pictorial challenge of antique heritage. The versatility of Dutch painters with the open mouth could be seen to emulate the accomplishment of Polygnotus, an ancient Greek painter, who, in the words of Pliny, 'made many improvements to technique, painting the lips parted to reveal the teeth, which brought expression to the face in place of the rigidity of former times.'

Loudmouthed pictures of manners by painters such as Brouwer, Hals, Rembrandt, and Steen were admired and collected for their capacity to express raw, recognisable emotions, as unpalatable as they might be. Nevertheless, it is fair to say that their commitment to brassy, edgy sound was not for everyone, and mostly lost favour by the end of the seventeenth century. The rough trade that populates the choice grisaille pictures of Adriaen van de Venne, which had strong and elite market appeal in the second quarter of the century, began to outstay its welcome. Portrait painters, who were traditionally challenged to render their sitters' capacity for speech as an indication of thoughtful presence, continued to infuse their paintings with gentler sounds. These modest tactics had greater staying power. Parting the lips but slightly, at all costs concealing teeth and tongue, was a decorous solution for the indication of incipient speech. Rembrandt got it just right in his striking portrait of Cornelis Claesz Anslo, a famously eloquent Mennonite preacher, finished in 1641 (fig.9). Anslo extends his left hand in what was a standard gesture of demonstration, and he has a female listener turn her ear rather than her eyes toward him, absorbing his words rather than his exterior appearance.

Despite the manifold efforts to relieve painting's muteness with sound and speech, the predominant march of Western painting since the Renaissance has been towards silence, or at least towards quieter kinds of painting, towards a modern kind of painting that accepts, embraces, even trumpets its own silence, the better to turn in on itself and place the viewer into a position of hushed attention.

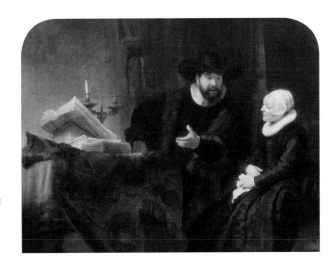

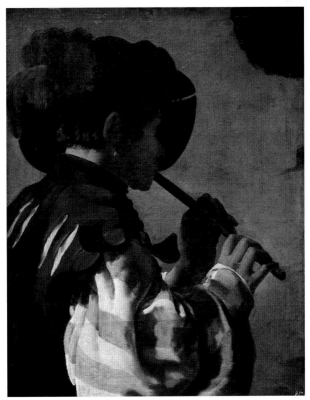

Paintings of manners track this directionality. Gerard ter Borch's fine picture of *A Young Woman at her Toilet with a Maid* (The Metropolitan Museum of Art, New York), painted around 1660, marks it, but as early as 1621 Ter Brugghen's musicians could already appear muted (fig.10). In both pictures the profile view, suggesting withdrawal rather than extroversion, lowers the volume.

That painting's silence is its virtue is such an entrenched notion today that it seems natural, without a history, the way things should be. And painting's muteness demands ours in return. We find it annoying, usually, if a group of schoolchildren loudly bustles through our favourite gallery; we find it acceptable, by and large, if museum guards hush our conversation in front of a picture. Quiet thought was surely not the prevailing mode of regarding Dutch paintings of manners when they were still in their painters' studios or owners' cabinets more than three centuries ago – and certainly not the ones by Brouwer and Steen illustrated here. We find references, casual ones mostly, in joke books, diaries and artists' biographies, even in paintings themselves, of people talking in front of paintings, pointing out amusing, clever and tragic details. Yet in seventeenth-century Dutch cities, certain kinds of paintings, including pictures by Ter Brugghen, Ter Borch, and Vermeer, made novel efforts to be true to the silence that distinguishes painting from poetry.

This case is most easily made for still life – the genre that has always been demonstrative about its studio origins (fig.11). Willem Claesz Heda's composition of domestic finery and food is still, and not just because its objects are speechless. Heda arranged his studio objects – which, as true studio props, recur time and again in his pictures – in such an unlikely way, and he gave them such a meticulous finish, that his painting of them asks us to attend to them in a manner we would not in daily life, unless we were scientists studying the optics of reflection or connoisseurs handling luxury objects. (These types of men of learning and taste, not coincidentally, were increasingly well represented in the Dutch Republic.) In the second half of the century, even painters of manners, that most social and inherently soundful of genres, began to court the dual silence of Heda's still lifes – that of the picture and that of the viewer.

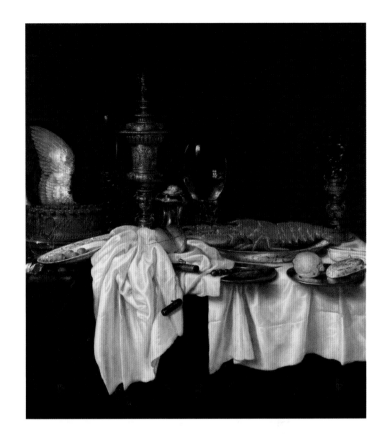

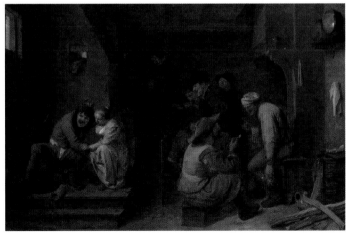

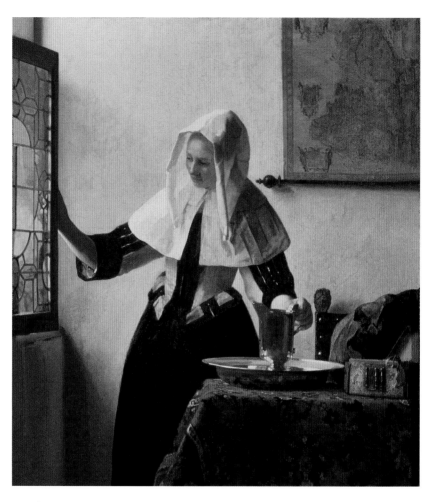

FIG.13 | JOHANNES VERMEER (1632–1675)
*Young Woman with a Water Jug*, 1662
Oil on canvas 45.7 × 40.6 cm
Marquand Collection, Gift of Henry G. Marquand, 1889
The Metropolitan Museum of Art, New York

That they should have done so is far from self-evident. Take the tavern enter-
tainments of peasants. In early inn scenes such as Adriaen Brouwer's, drinking and
gaming often turned clamorous and violent, as we know from the law enforce-
ment (fig.12). Brouwer's pupil Adriaen van Ostade started out painting such bois-
terous pictures in the 1630s, but by the time this respectable citizen of Haarlem
had struck out on his own and was painting tavern scenes in the 1640s, they had
become decorous afternoon gatherings, virtual family affairs. Van Ostade's revel-
lers are distanced by their smaller relative size, and they are bathed in a warm but
clean, unifying light.

While most Dutch pictures quieted down after about 1650, silence was nowhere
more golden than in the domestic interior. We usually think of Johannes Vermeer
as the inventor of the hushed Dutch home, in pictures of women reading, hold-
ing a balance, or merely touching a pitcher (fig.13). While Vermeer, long known
as the Sphinx of Delft, surely deserves his moniker, his silent spaces owe much to
the interior concepts of others, perhaps most directly those of Gerard ter Borch,
whom he met in 1653, at the outset of his career. One might hear a pin drop in
Ter Borch's scene of a solitary woman, spinning in domestic quarters (Museum
Boijmans Van Beuningen, Rotterdam). Several of Ter Borch's favourite tricks pro-
duce this effect. The isolation of the figure and her steadfast refusal to look at us or
anyone else suggest that she will forever concentrate on her task, undisturbed. The
darkened background, devoid of visual distraction, forces our concentration not
only on the figure, but also on the astonishing virtuosity with which the painter
distinguished the optical appearances of objects: deep brown ebony, lighter elm
wood, wool, velvet, ermine, dog fur, hair. Our perception of Ter Borch's consum-
mate attentiveness to the differential reflection and absorption of light by diverse
materials calls for an analogous concentration in us: a visual attention as hushed
and dedicated as that of the painter and of his protagonist.

Even Ter Borch's scenes of social engagement are remarkably restrained, com-
pared to the exuberant sound pictures of his contemporary Jan Steen: how gentle
his suitor's inquiry, how tender the tones of a lute compared with Steen's raucous
notes, how implausible, even, the song issuing from the lips of a woman singing
(*The Suitor's Visit*, National Gallery of Art, Washington). When Ter Borch paints

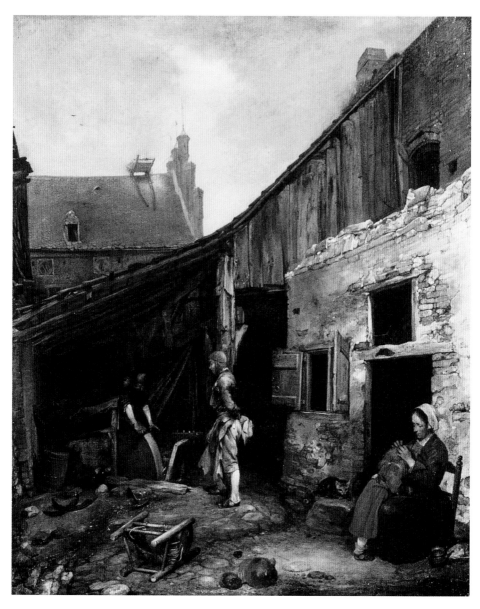

FIG.14 | GERARD TER BORCH (1617–1681)
*Knifegrinder's Family*, 1653–5
Oil on canvas 73.5 × 60.5 cm
Gemaeldegalerie, Staatliche Museen zu Berlin

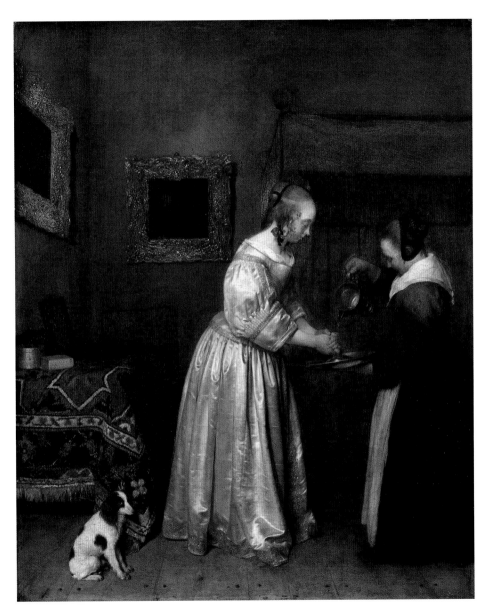

FIG.15 | GERARD TER BORCH (1617–1681)
*Lady Washing her Hands,* 1655
Oil on oak panel 53 × 43 cm
Gemaeldegalerie Alte Meister, Staatliche Kunstsammlungen, Dresden

a *Knifegrinder's Family*, who would guess that his quiet family idyll is set to the deafening racket of the metal edge of a scythe against the rotating stone (fig.14). And if Ter Borch's painting of a *Lady Washing her Hands* makes us hear anything, it is the gentlest tinkling of water into the basin (fig.15). Here, the actor with the greatest potential for disturbing the peace, a little spaniel, models our expected silence, pertly regarding us with his mouth shut tight. As so often, Ter Borch compels us to oblige by his high-resolution renderings of the textures of the world of common objects. Much as if scrutinizing a still life, we fall silent as we linger over keenly observed details we would pass over in our daily routine.

Ter Borch's mute paintings of manners appear eager to promote painting's distinguishing silence, and he must have passed on that notion to his talented family. His sister Gesina, who produced hundreds of wonderful drawings of contemporary love, labour, and leisure, drew a personification of Painting as a youthful woman, seated at an easel with Poetry by her side, her mouth bound with an orange band (*Allegory of Painting*, Rijksprentenkabinet, Amsterdam).

Gesina's gentleman friend, Jordis, wrote an elaborate piece on the scene, explaining that 'Poetry stands beside Painting because she is Painting's sister… the one using the tongue to tell the ears what the other speaks to the eyes with the brush, wherefore the one is called mute poetry and the other the speaking kind.' By the 1670s, these were of course standard metaphors. However, the author's explicit rationale for the prominent gag around Painting's mouth was new: 'The bound mouth means that nothing is more advantageous to her, than aloneness accompanied by silence and tranquility, which is why those who practice and love this art of painting favour secluded places, the better to hold together their thoughts and senses.' Here painters as well as paint lovers are credited with a penchant for quiet contemplation not unlike that practiced in and stimulated by the paintings of Gesina's father Gerard. The silence of painting in the Ter Borch family practice, then, is triplex: the silence of the painter begets the silence of the painting begets the silence of the viewer.

Students of Ter Borch's paintings have long noted their refusal to address their viewers directly, and their concomitant hesitation to communicate unambiguously. That refusal produces another kind of silence, an inconclusiveness of

meaning, where silence hangs in the air. In the literature of art history, Ter Borch's so-called *Paternal Admonition* is the most celebrated case of this instability, variously interpreted as a scene of stern or kindly parental advice, a prostitution deal, or a refined courtship ritual (fig.16). The composition became well known first because Ter Borch and his studio issued several versions of it, but especially after Johann Georg Wille published a fine engraving of it in 1765, with the designation *Instruction Paternelle*. Goethe, in his novel *Die Wahlverwandtschaften* (1809), elaborated and solidified that interpretation by describing the scene as a paternal admonition marked by the reasonable restraint of all parties. The 'noble, knightly looking father' addresses the daughter's 'conscience'; although seen from behind, her 'whole bearing appears to signify that she is collecting herself;' and the mother gives off 'slight embarrassment' by 'looking into a glass of wine, which she is on the point of drinking.' An unnoticed but colourful parody of Goethe's delicate description was offered by an English art publisher in the late nineteenth century, as a commentary to an engraving modelled on Wille's. The long description is worth quoting in full because it seems to get crucial aspects of the picture and Ter Borch's hopes for it, no matter what the character of the scene:

*There seems, at the first glance, to be very little in the picture; and a considerable portion of what there is can scarcely be called attractive.*

*We can fancy any thing we choose about the face of the daughter. She may be a dazzling beauty, or as ugly as Dutch women can be, for all that we can say. She may be laughing or weeping, good-natured or pouting, it is all one to us. As for the mother, she evidently leaves family affairs to the husband; and whether she approves the counsel he is giving their daughter or not, we shall never know, though we may legitimately infer from her placid air that she approves of the draught she is drinking.*

*The father looks like a very prosy old fellow, and we may congratulate ourselves that we cannot hear a word of his discourse. What, then, is it that makes this picture a masterpiece, with a world-wide fame? Why, it is the white satin gown, which is, in reality, the whole raison d'etre of the work. This gown is known to all artists. It is the despair of hundreds of them, who would wish to paint as well as it is painted, but they cannot, try as they may.*

*It is for the sake of the gown that the girl turns her back to us; for the sake of the*

*gown that the parents are there, that the father forever holds up his thumb and fore-finger, and the mother endlessly sips her wine. And there is more philosophy in it than at first appears; for, when Terburg [sic] painted this gown, he did what few have ever done, – he made a costume which was admired at first, has always been admired, and still is, though more than two hundred years old.*

As this account implies, just because the painting is silent does not mean it is disinterested in claiming our attention. 'It's the dress, stupid,' the author seems to say, and what the dress does for the painter, and his ability to make us see anew with his sharp eyes (see fig.16). This is one of the claims that modern painters made so successfully for their art, before other representational technologies started to challenge its primacy. Ter Borch and Vermeer are among the Dutch artists who spearheaded this development by promoting painting's silence. Ter Borch fostered silence by demanding that we attend to his uncanny capacity for rendering the materials of the world, which had become a heightened expectation of oil painting in seventeenth-century Holland. Ter Borch met this requirement consummately, as he did most spectacularly in *A Lady at her Toilet* from the Detroit Institute of Arts (fig.17). Objects painted with this finesse demand our taking notice of just how a piece of satin can shimmer and shine by taking on subtle shades of its environment – brownish floors, reddish table carpets, and so on. Such an aware type of looking is not unlike the experience of regarding the perfectly smooth, pellucid, silent images produced in mirrors. Ter Borch and his peers were acutely aware of the mirror-like character of their art, and they frequently, as here, inserted the newly popular flat toilette mirrors into their most specular paintings. Just how the mirror became a newly active metaphor, model, and prompt for painting, and how that analogy opened up new, though quiet, ambitions for modern painting, is a subject for another essay.

And yet, when you look as closely as Ter Borch dares you to, you see the madeness of what looks mirrored when you stand back. Noticing virtuoso details such as a slightly darkened, greenish glass in front of an ermine collar, or the slivered white touches that give definition to copper coins (*A Man Offering a Woman Coins*, Musée du Louvre, Paris), or the burst of highly saturated white brushwork that locates a knee underneath a satin skirt, all the while knowing that they are

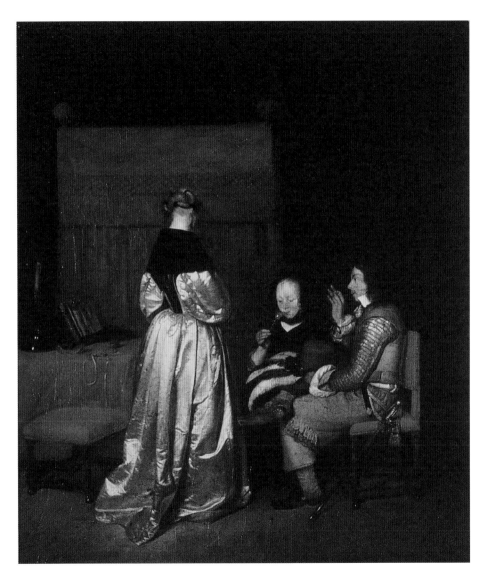

FIG.16 | GERARD TER BORCH (1617–1681)
*The Paternal Admonition, c.1654*
Oil on canvas 71.4 × 62.1 cm
Rijksmuseum, Amsterdam

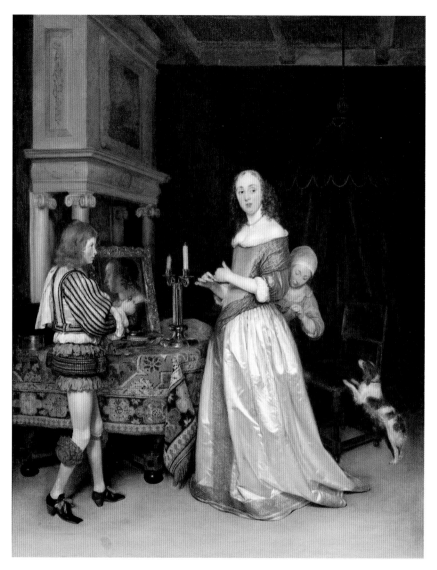

FIG.17 | GERARD TER BORCH (1617–1681)
*A Lady at her Toilet, c.1660*
Oil on canvas 76.2 × 59.7 cm
The Detroit Institute of Arts, Detroit

paint, and yet seeing the illusion, and then saying to yourself, 'no, no, it *is* paint' – such a process of aware looking brings you in a mind-to-hand relation to the artist who put the fiction there. This consciousness born of close looking conjures the past mental and physical presence of the artist before the picture in the making. Our simultaneous awareness of illusion and paint, that endlessly fascinating aspect of all painting with a mimetic brief, makes looking at pictures of this kind an inter-personal experience across centuries. Studying Ter Borch's dress as painting (see fig.16), we become aware that there must have been a governing intelligence who made it, wedged it into its pictorial space in a persuasive manner, carefully dangled that casual foot before its ground, looked at it all again and again, adjusted it for more compelling effect, and finished it so that we may, as the nineteenth-century observer suggested, be forever challenged by it.

But was *The Paternal Admonition* really all about the dress? In their quietest pictures, Vermeer and Ter Borch had their solitary protagonists model the attentive, silent, and absorbed looking that their paintings demand (Johannes Vermeer, *A Girl Reading a Letter by an Open Window,* Gemaeldegalerie Alte Meister, Staatliche Kunstsammlungen, Dresden and Gerard Ter Borch, *Woman Writing a Letter,* Mauritshuis, The Hague). That looking, so akin to our own, generates an illusion more powerful than that of the satin dress as textile object: the uncanny sense that the painting has within it a thinking subject much like us.

Ter Borch and Vermeer toned down the noise to the rustle of a letter. They are extreme paragons of a broader development, and painterly sound never disappeared altogether. Jan Steen's noisiest paintings are contemporary with Ter Borch's and Vermeer's, and in a sense they protest against the way silent interior pictures disavowed a rich Netherlandish tradition of comic paintings of manners, which Steen had inherited and updated from Bruegel and Brouwer. Sound and noise have enjoyed a revival in contemporary painting since the advent of Pop Art – what picture could be more soundful than Roy Lichtenstein's *Popeye* of 1961. But in Ter Borch's time, audible painting fought a losing battle, to the benefit of painting that exploited its foundational silence to promote contemplative looking and to play up the thoughtfulness of the painter. There is more philosophy in it than at first appears.

Although the rise of silent painting in the Dutch Republic has been argued here primarily from the evidence of the pictures, it had a complex social ground in the post-Reformation city. In this environment, the artist's studio and the reader's study could flourish. Private prayer and silent reading at home offered non-visual analogues to the practices of making and looking at cabinet painting. Those developments in mental activity as well as the enhanced muteness of painting were accommodated and stimulated by the private spaces of the modern city that became the new stage for Dutch pictures of manners after 1650 (Johannes Vermeer, *Woman in Blue Reading a Letter*, Rijksmuseum, Amsterdam). In practice and in representation, these domestic sanctuaries define themselves in significant measure by their capacity to shut out the sounds of the world. In the Dutch Republic the citizen elite built such sound-proofed homes in unprecedented numbers, yielding acres of wall to the triumph of silent poetry.

# FURTHER READING

BROWN, 1984
Christopher Brown, *Scenes of Everyday Life: Dutch Genre Painting of the Seventeenth Century*, London: Faber & Faber, 1984

DUPARC & WHEELOCK, 1995
Frederik J. Duparc and Arthur K. Wheelock, *Johannes Vermeer*, exh. cat., Mauritshuis, The Hague, Zwolle: Waanders, 1995

FRANITS, 2004
Wayne E. Franits, *Dutch seventeenth-century genre painting: its stylistic and thematic evolution*, New Haven: Yale University Press, 2004

HAAK, 1984
Bob Haak, *The Golden Age: Dutch Painters of the Seventeenth Century*, London: Thames and Hudson, 1984

JANSEN, 1996
Guido M. C. Jansen (ed.), *Jan Steen: painter and storyteller*, exh. cat., National Gallery of Art, Washington, DC, New Haven: Yale University Press, 1996

LIEDTKE, 2008
Walter Liedtke, *Vermeer: the Complete Paintings*, Antwerp: Ludion, 2008

SLIVE, 1995
Seymour Slive, *Dutch Painting: 1600–1800* (revised and expanded), New Haven: Yale University Press, 1995

WESTERMANN, 1997
Mariët Westermann, *The amusements of Jan Steen: comic painting in the seventeenth century*, Zwolle: Waanders, 1997

WHEELOCK, 2004
Arthur K. Wheelock Jr (ed.), *Gerard ter Borch*, exh. cat., National Gallery of Art, Washington, DC, 2004